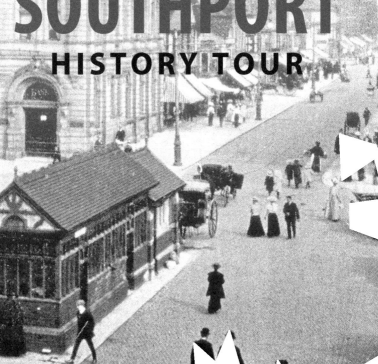

# SOUTHPORT
## HISTORY TOUR

# ACKNOWLEDGEMENTS

Thanks to Martin Perry for his generosity in supplying the archive photos from his magnificent collection of postcards, for his vast knowledge of Southport and for proofreading. To Paul Hollinghurst for the production of the maps. To Pam Whelan for the photo on pages 24–25.

To the following authors and books: Peter Aughton, *North Meols and Southport*; F. A. Bailey, *A History of Southport*; Harry Foster, *New Birkdale*; Harry Foster, *Southport: A History*; Cedric Greenwood, *Thatch Towers and Colonnades*; and Jack Smith, *Southport Through Time*.

*To my wife Joan above all for her encouragement,*
*patience and understanding*

First published 2018

Amberley Publishing
The Hill, Stroud,
Gloucestershire, GL5 4EP
www.amberley-books.com

Copyright © Hugh Hollinghurst, 2018
Map contains Ordnance Survey data
© Crown copyright and database
right [2018]

The right of Hugh Hollinghurst to be identified as the Author of this work has been asserted in accordance with the Copyrights, Designs and Patents Act 1988.

British Library Cataloguing in Publication Data.
A catalogue record for this book is available from the British Library.

ISBN  978 1 4456 8511 3 (print)
ISBN  978 1 4456 8512 0 (ebook)

Origination by Amberley Publishing.
Printed in Great Britain.

# INTRODUCTION

Southport started from the parish of North Meols and Churchtown. William Sutton, landlord of the Hesketh Arms public house (or Black Bull as it was known then) profited from housing and transporting bathers from there to South Hawes, near the south-west end of Lord Street. Known as the Old Duke, William first built a bathing shelter and then in 1798 added hotel accommodation, dubbed 'The Duke's Folly', to save them the 2-mile drive each way every day. It is said that at the opening entertainment a Dr Barton took a bottle of wine, and dashing its contents about him, emphatically said 'This place shall be called Southport.'

Churchtown itself goes back to Viking times. St Cuthbert's coffin may have rested there, on the site of the church, when it was carried round the north of England in the ninth century to save it from desecration by invading Vikings. North Meols was mentioned in the Domesday Book and Adam the Clerk is recorded in 1178 at the head of the list of rectors on wooden boards inside the church. Meols Hall is the seat of the Hesketh family who, together with the Bold family, were the lords of manor who created Southport in the nineteenth century. A hall has stood on the site since the reign of King John and has passed down through twenty-seven generations to the present owner. The main building dates from the middle of the sixteenth century.

The opening of the Victoria Baths in 1839 was a highlight in the development of seafront facilities, further enhanced by the pier, the longest in the country, in 1860. Two Marine Lakes were created in the late nineteenth century. Indoors, the Winter Gardens entertainment complex between Lord Street and the Promenade was opened in 1874. The site encompassed a grand terrace on the Promenade side, a Crystal Palace-style conservatory stated to be the largest in England, a Promenade Hall and the Pavilion Theatre. The associated Opera House opened in 1891. When it burnt down in 1929 it was replaced by the

Garrick Theatre, one of an eventual thirteen cinemas. Leisure time could be spent more peacefully in the Botanic Gardens Museum, which opened in 1868, or in Hesketh Park, which was created in 1875.

Meantime, on Lord Street, the Town Hall (1854) was the first of the array of buildings constructed in a classical style followed by Cambridge Hall (1874), designed for public meetings. The growing prosperity and wealth of the town was reflected in its grand commercial architecture. Albany Buildings with its twin gables is the first and finest example, dating from 1884. The outstandingly ornate Preston (later Midland) Bank of 1888 was followed by others competing in grand classical style until the 1920s. The Wayfarers Arcade (originally the Leyland Arcade) opened in 1898. The Monument, unveiled on Remembrance Day in 1923, was the culmination of classical adornment giving a focal point to the whole of Lord Street. Hotels of distinction abounded, most notably the Prince of Wales and the Royal Clifton, along Lord Street and the seafront respectively, which became two magnificent promenades.

Southport's motto on its coat of arms advertised '*salus populi*', 'the health of the people'. Besides its sea bathing, this was improved by hydropathic establishments including Smedley's and the Palace Hotel in neighbouring Birkdale in the 1870s and '80s. Birkdale was an urban district council until 1912 when it was incorporated into Southport. It had its own imposing town hall, which was unfortunately pulled down in 1971.

These attractions were well served by the town's transport network. Guidebooks boasted that Southport had probably a greater length of tramway – in proportion to population – than any other town in the United Kingdom. Special excursion platforms on Chapel Street station were constructed to cope with the influx of visitors during the summer months. A rival line was engineered into Lord Street, just by the Winter Gardens, in a deal that created a seafront wall and Victoria Park, the home of the Flower Show. Horse-drawn carriages were still popular with visitors until after the Second World War.

After this, however, the motorcar took over and the excursion platforms were converted into a car park. Even then Southport could not compete with the changing patterns of holidaymakers who flew to Spain or drove to Blackpool. Even the pier came under threat and was only saved by a single vote in the council and the injection of 'foreign' money. By the 1950s there were thirteen cinemas in Southport, nine of them on or near Lord Street. Now there is only one: a newly built multiplex on the seafront. Two of those on Lord Street survive from that period as bingo halls. Most of the other grand old buildings still exist including The Atkinson – art gallery, museum, library and theatre. It has been newly refurbished, providing fresh cultural opportunities and hope for the future.

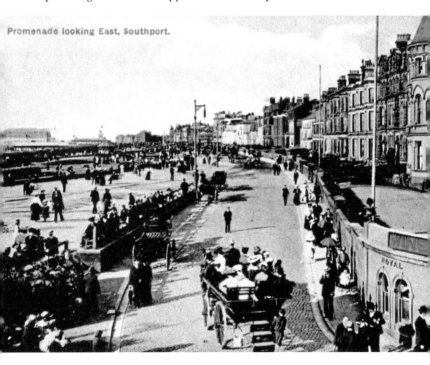

Promenade looking East, Southport.

# KEY

1. St Cuthbert's Church
2. Churchtown School
3. Thatched Cottage
4. Hesketh Arms
5. Botanic Gardens Museum
6. Botanic Gardens Co.
7. Botanic Gardens Attractions
8. Botanic Gardens Conservatory
9. Meols Hall
10. Hesketh Park
11. Tram Depot
12. London Square
13. The Monument
14. Monument Inscriptions
15. Banks
16. Columns, Canopies and Colonnades
17. Nevill Street
18. Albany Buildings
19. Midland Bank
20. Wayfarers Arcade Entrance
21. Wayfarers Arcade
22. Town Hall
23. Cambridge Hall
24. Bandstands
25. South Port Hotel
26. Opera House
27. Garrick Theatre
28. Lord Street Station
29. Victoria Park and Rotten Row
30. Royal Hotel
31. Royal Clifton Hotel
32. Beach
33. 'New' Promenade
34. Lifeboat Memorial
35. Pier Construction
36. Pier Head
37. Pier Amusements
38. Pier Transport
39. Victoria Baths
40. Floral Hall and North Lake
41. Promenade Convalescent Hospital
42. Birkdale Palace Hotel
43. Birkdale Town Hall
44. Smedley's Hydro
45. Cambridge Hall Bandstand

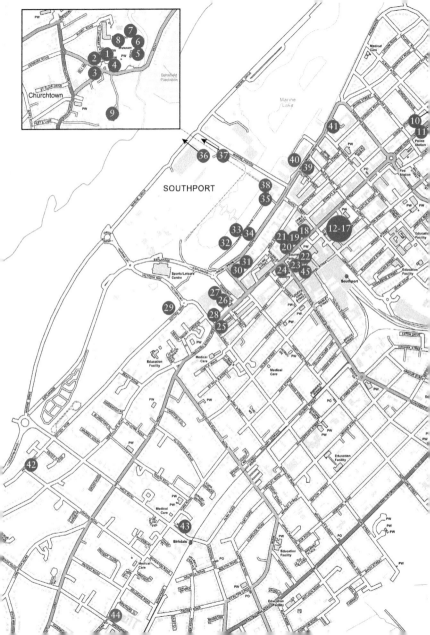

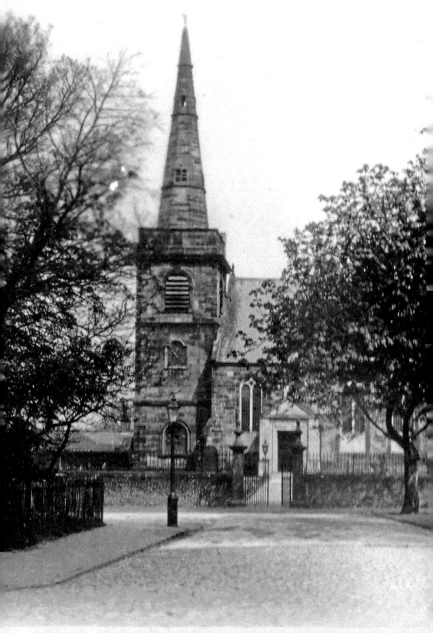

# 1. ST CUTHBERT'S CHURCH

St Cuthbert's coffin may have rested here when it was carried round the North of England in the ninth century to save it from desecration by invading Vikings. North Meols was mentioned in the Domesday Book and Adam the Clerk heads the list of rectors in 1178. The present building dates from 1739 but with substantial rebuilding from the nineteenth and early twentieth centuries. Built into the graveyard wall are stocks last used in 1860.

## 2. CHURCHTOWN SCHOOL

Between the church and the thatched cottage (*see* No. 3) is the Grammar School. Founded by the end of the seventeenth century, it was replaced in 1826 by primary or national schools. The plaques for the boys' and girls' schools can be seen on the wall together with the one recording the enlargement of 1837 to create an infant school. The building has been used for other purposes since a new school was built in 1859.

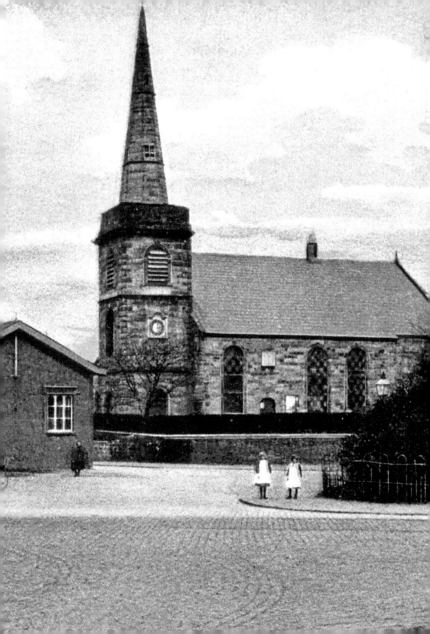

# 3. THATCHED COTTAGE

Churchtown sports twenty thatched cottages, more than any other district in Sefton. The prevalence of thatch was due to its ready availability compared with distant supplies of stone or slate. Many have cruck or A-frames with wattle and daub. Most face south or south-east to catch the sun. Attached to this possibly seventeenth-century cottage, unusually of two storeys, is a tombstone in memory of 'A good & faithful dog'.

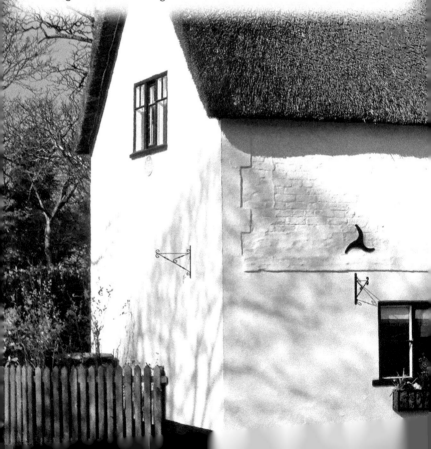

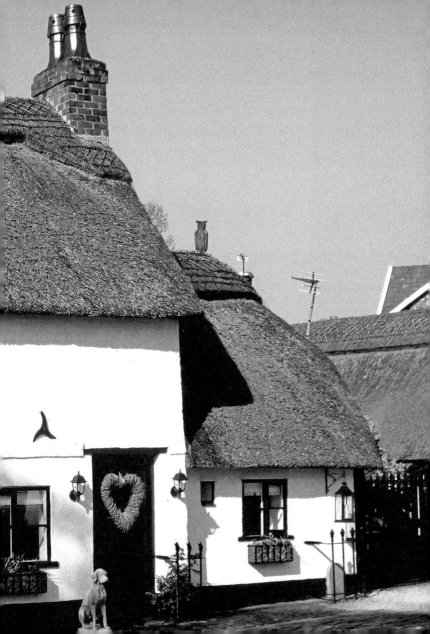

# 4. HESKETH ARMS

The Hesketh Arms public house played an important part in the birth of Southport. William Sutton, landlord of the Black Bull (as it was known then), profited from housing and transporting bathers from Churchtown to South Hawes where the south end of Lord Street is now. William erected temporary accommodation there for the bathers and then constructed a new bathing house on the site to save them the 2-mile drive each way every day.

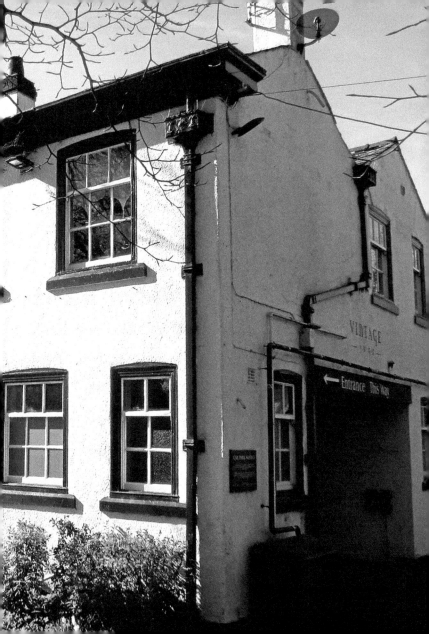

# 5. BOTANIC GARDENS MUSEUM

The museum was opened the year after the gardens as a private company. The collection, consisting mainly of curiosities, was sold in 1933 when the company failed. Southport Municipal Museum was opened in its stead in 1938, displaying items of local interest: artistic, scientific, historical, and cultural. These included a collection of birds and dolls, and an ancient canoe from Martin Mere, which were all dispersed when it was closed again in 2011 due to council cutbacks.

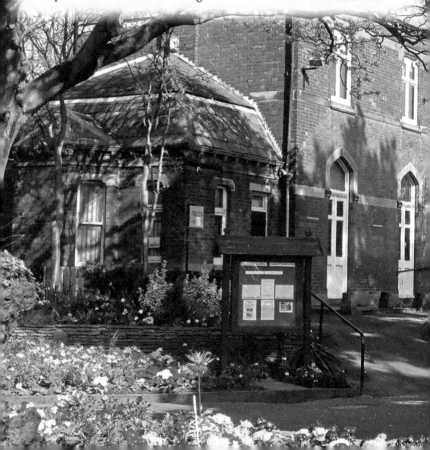

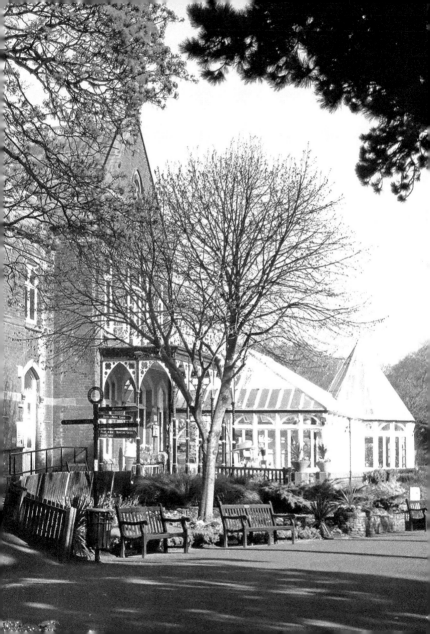

# 6. BOTANIC GARDENS CO.

Revd Charles Hesketh opened the gardens in 1875. They were created by the Southport & Churchtown Gardens Co., a group of working men who acquired the land from the Hesketh estate and raised £18,000 (nearly £2 million today) to build the museum and conservatory, and landscape the gardens. Before that the principal attraction to visitors in Churchtown was the 'Strawberry Garden' where visitors could enjoy strawberries and cream under cover, as also later in Southport's Kew Gardens.

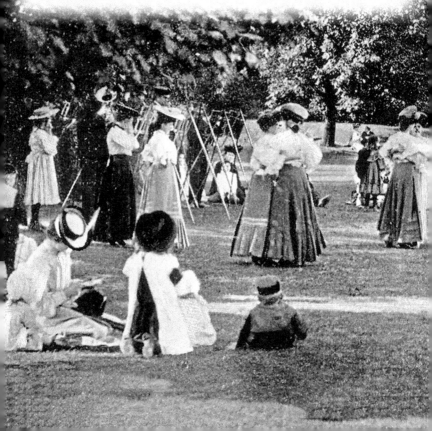

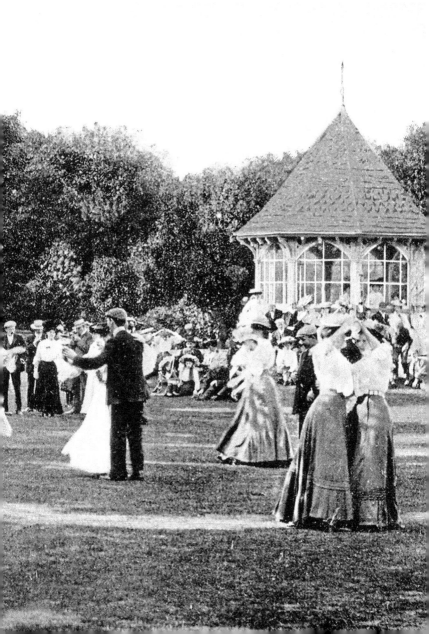

## 7. BOTANIC GARDENS ATTRACTIONS

When the gardens opened opened, 4*d* (£1.75 today) was charged for entry to a variety of attractions that at one time included boats on the lake, a monkey house and more recently a road train. Only an aviary has survived. When the Botanic Gardens Co. failed in 1933, the gardens were purchased in 1936 by the Corporation with generous aid from Roger Fleetwood Hesketh.

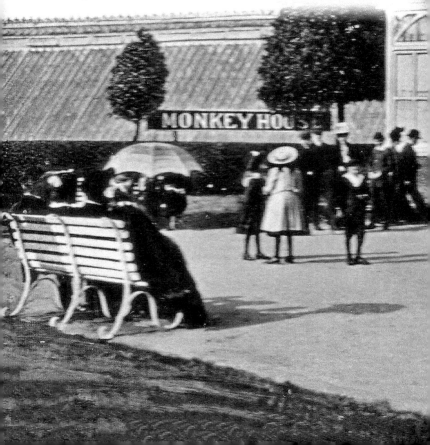

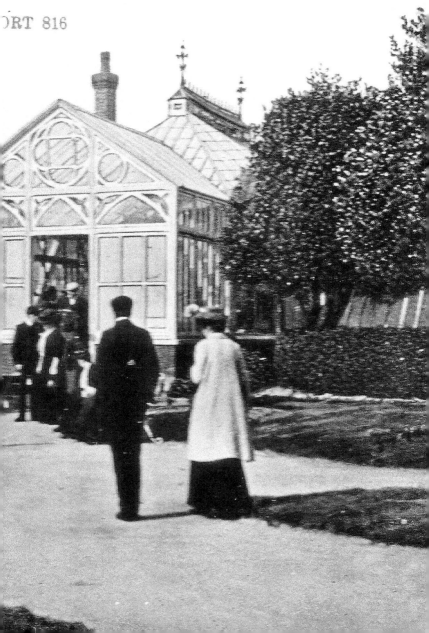

# 8. BOTANIC GARDENS CONSERVATORY

Besides the large glass conservatory the gardens boasted a fernery, which proved very popular with visitors as it featured many tropical plants from around the world. Although the magnificent conservatory was eventually demolished, the fernery still remains. The site of the conservatory can still be seen in front of the fernery today, as the outline of the remains is laid out as a floral garden. The lake is a remnant of an inlet of the sea.

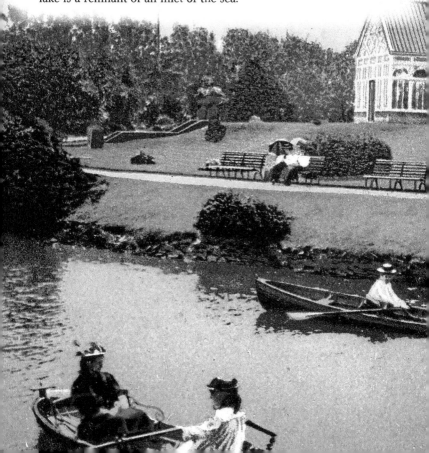

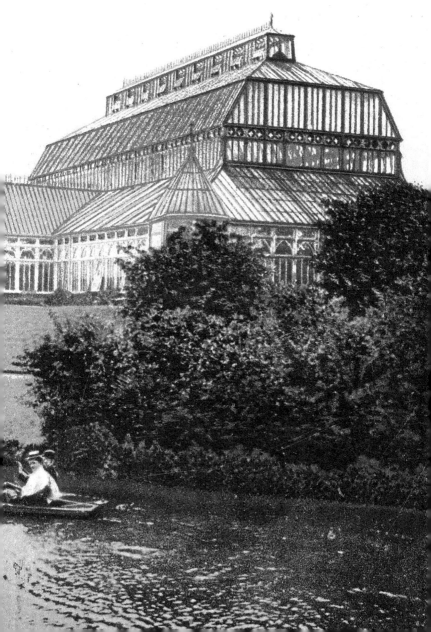

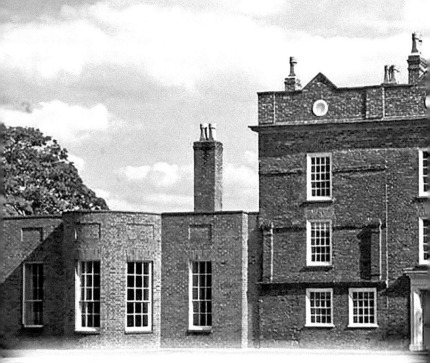

# 9. MEOLS HALL

The hall is the seat of the Hesketh family. Together with the Bold family, they were the lords of manor who created Southport in the nineteenth century. Meols Hall has stood on this site since the reign of King John and passed through twenty-seven generations to the present owner. The main building dates from the middle of the sixteenth century with extensions to the south added in 1695 and further extensions each side in 1964.

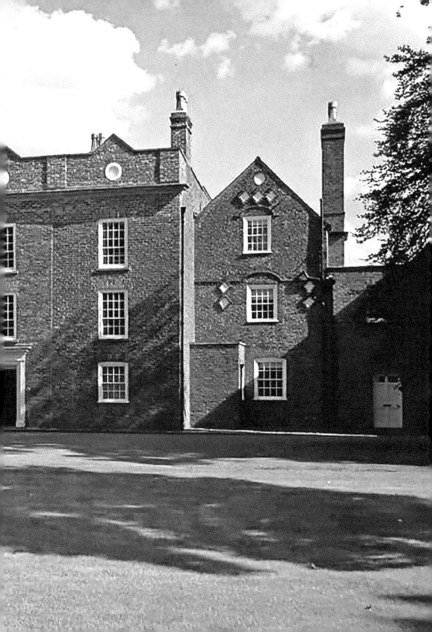

# 10. HESKETH PARK

Charles Hesketh, rector of St Cuthbert's Church and lord of the manor from 1842, gifted land called 'Happy Valley' for the park, which opened in 1868. He had been appointed one of the Southport Improvement Commissioners to improve the town. The park is enhanced by an observatory, a conservatory (moved from a villa on Lord Street in 1878) and a floral clock in the American Garden, recently replanted to its original 1930s design.

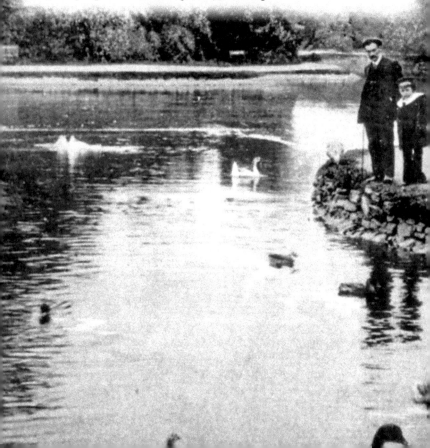

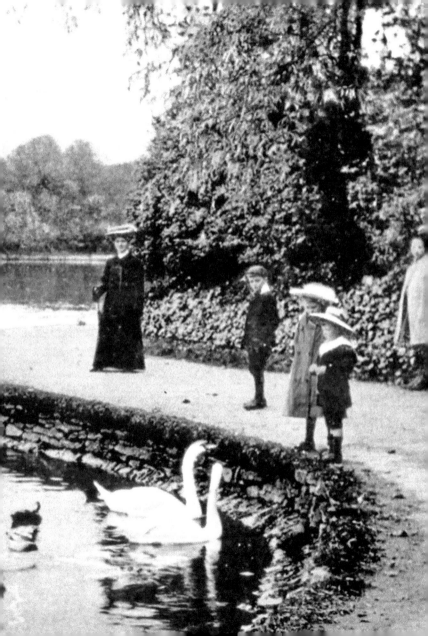

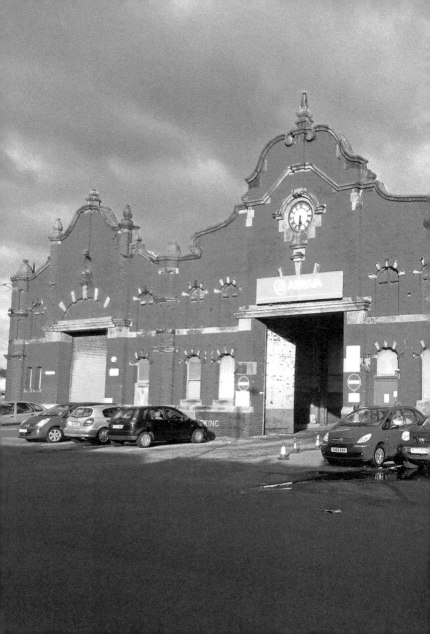

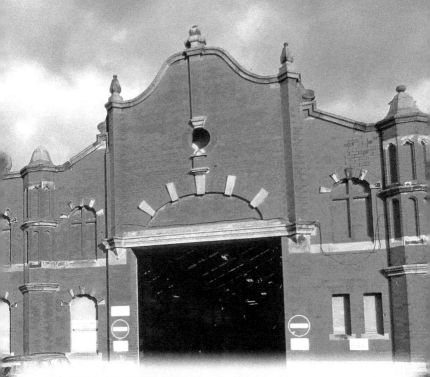

## 11. TRAM DEPOT

This imposing depot off Crowland Street in Blowick housed the first electric trams, which were introduced in 1900 (horse trams had operated from 1873). The elaborate decoration has suffered from disfigurement, poor maintenance and ugly accretions. Guidebooks boasted that Southport had probably a greater length of tramway – in proportion to population – than any other town in the United Kingdom. The network stretched from the Botanic Gardens to Birkdale but was dismantled at the end of 1934.

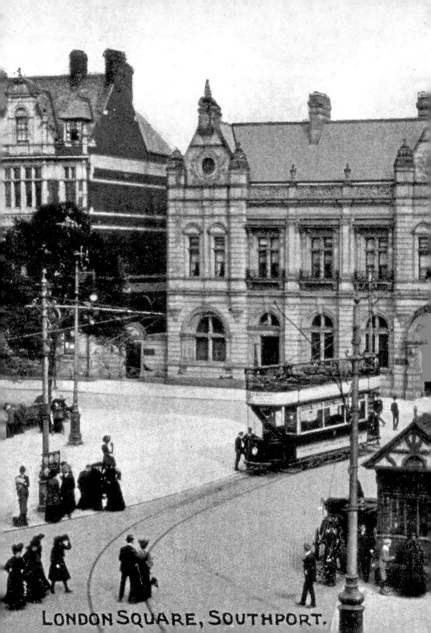

LONDON SQUARE, SOUTHPORT.

## 12. LONDON SQUARE

Before the Monument was built, the focal point of London Square was the building now replaced by the obelisk. It contained a waiting room and offices for trams – open top at the time. It was an important interchange: a spur diverged from the main tram line, which ran along Lord Street to Kew, and carriages were available for hire. On the left-hand corner is the National Westminster Bank of 1892.

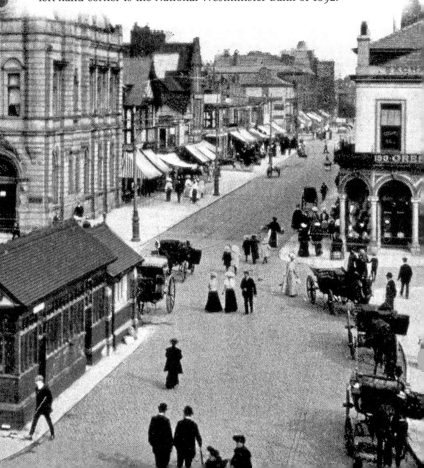

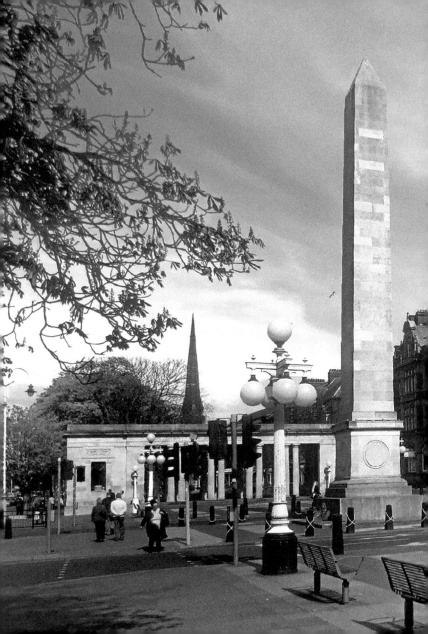

# 13. THE MONUMENT

The war memorial was unveiled on Remembrance Day in 1923. Great care was taken to ensure perfection. A competition for an architect attracted forty-five entries, which were judged by Sir Reginald Bloomfield from London. Local firm Grayson & Barnish of the Royal Liver building, Liverpool, was chosen. As Portland stone of the highest quality was not available because of high demand at the time for other war memorials, the committee waited a year for that and the stonemasons.

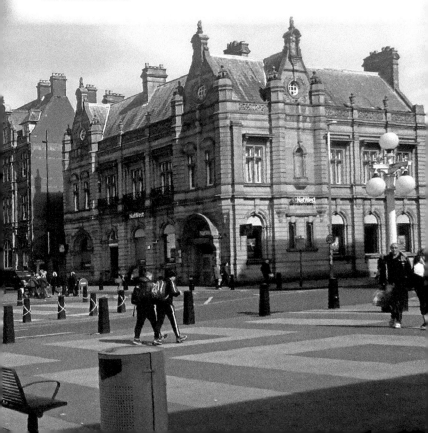

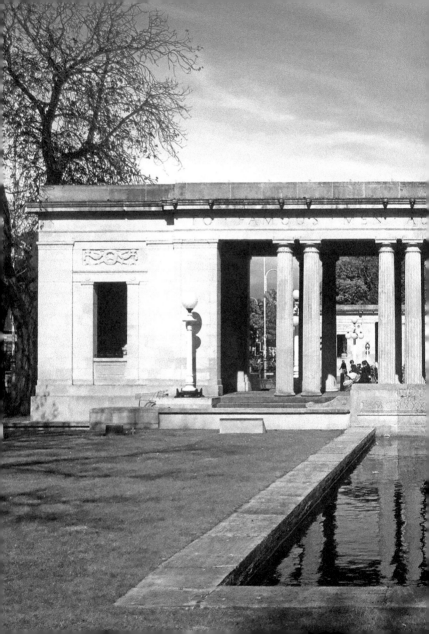

# 14. MONUMENT INSCRIPTIONS

Above the Doric columns on the inward-facing sides is, appropriately, a classically inspired inscription: 'TELL BRITAIN, YE WHO MARK THIS MONUMENT: FAITHFUL TO HER WE FELL AND REST CONTENT' (from Simonides' epitaph for the Spartans who died at the Battle of Thermopylae). On the other outward-facing sides is: 'TO ALL FAMOUS MEN ALL EARTH IS SEPULCHRE' (from Pericles' funeral speech to the Athenians recorded by Thucydides) and 'THEIR PORTION IS WITH THE ETERNAL'.

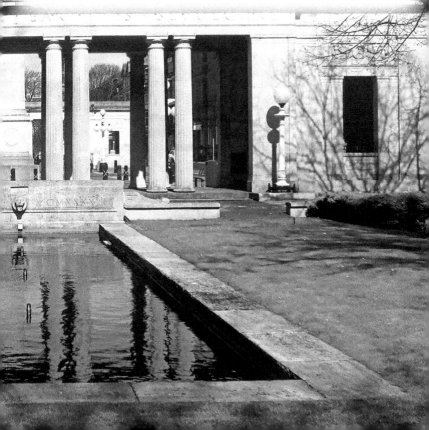

# 15. BANKS

A view from Lord Street along Nevill Street towards the sea shows how the corner sites have since been developed to transform London Square into a town centre of distinction and textbook showpiece of classical architecture. The Corinthian style of the National Westminster Bank, joined by the Doric of the Monument, was enhanced by the Roman Doric of the National and Provincial Bank (now Waterstones) and the Ionic of the former Lloyds opposite to it.

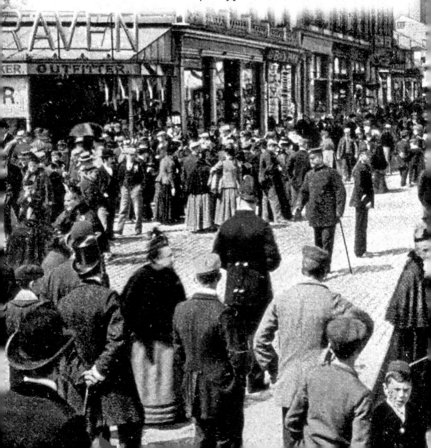

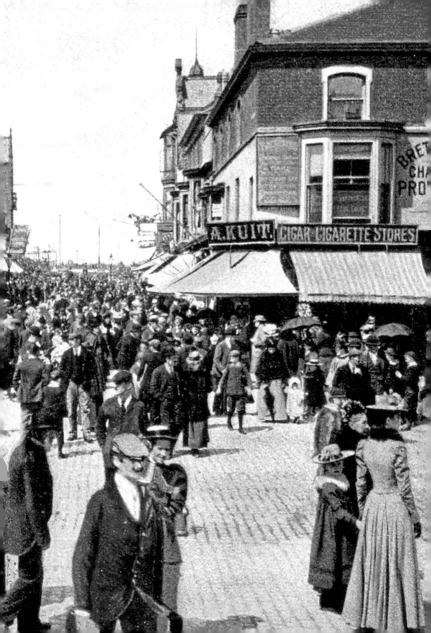

# 16. COLUMNS, CANOPIES AND COLONNADES

Elegant ladies embellish the foreground of this Edwardian image and two boy scouts are in step alongside. Equally elegant are the columns that support the canopies that fronted the shops. The Kardomah, advertised on the right, inveigled you upstairs into a café to enjoy the view of passers-by and horse-drawn equipages as illustrated. The canopies were joined into colonnades for rain- or sun-free promenading along most of Lord Street.

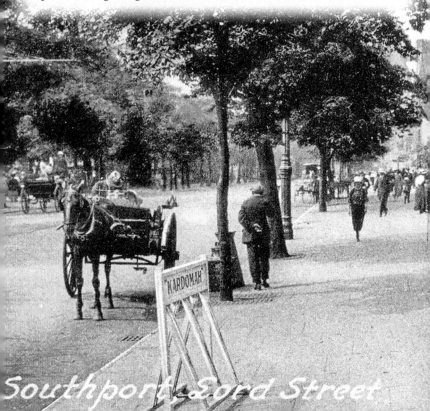

Southport, Lord Street

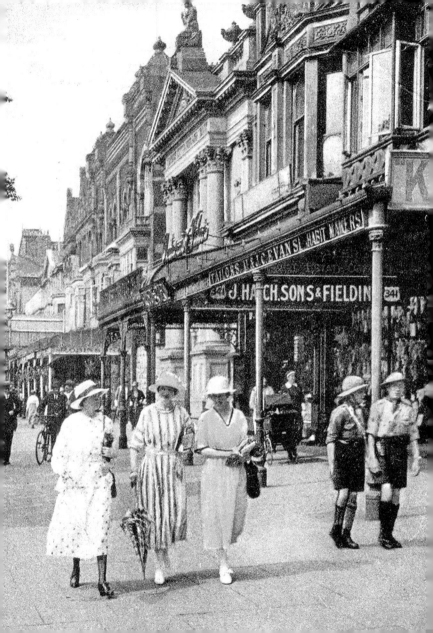

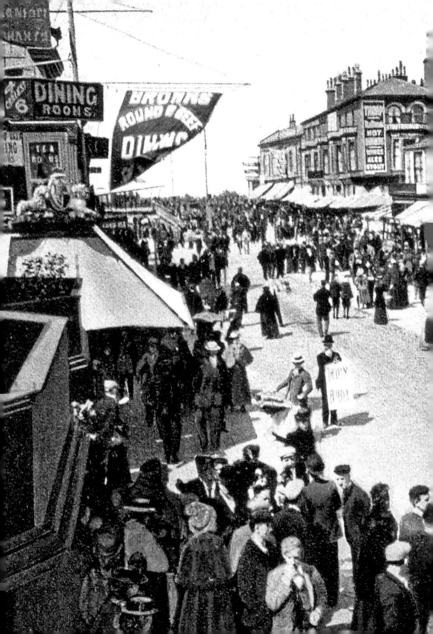

# 17. NEVILL STREET

This is the way excursionists would take from the station to the pier. In this Edwardian scene there is a standard uniform of boaters, caps, plain hats and jackets. Women are dressed smartly but not extravagantly. Many are advertising or plying their wares. Others cluster talking in groups or stride purposefully towards the pier. This contrasts with the sedate pace and decorous dress of the clientele of Lord Street, which they would have crossed while passing.

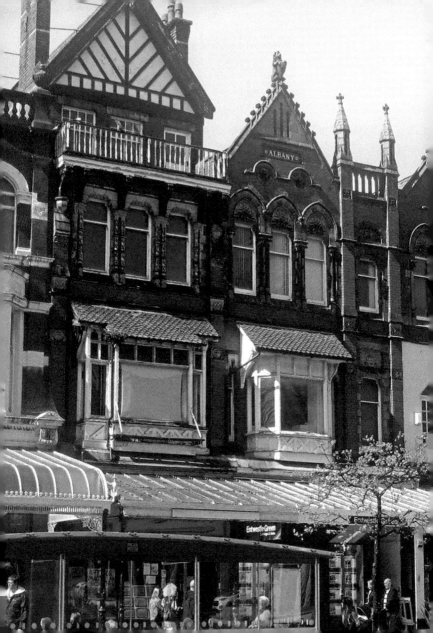

# 18. ALBANY BUILDINGS

The prosperity, wealth and ambition of the town in the late nineteenth century are reflected in its grand commercial architecture. Albany Buildings with its twin gables is the first and finest example, dating from 1884. Unfortunately, its former perfect symmetry and appearance have been spoilt by later alterations. Compare – left and right – the balconies, encaustic tiled classical pillars flanking the windows with Gothic overarches, oriel windows and shop frontages.

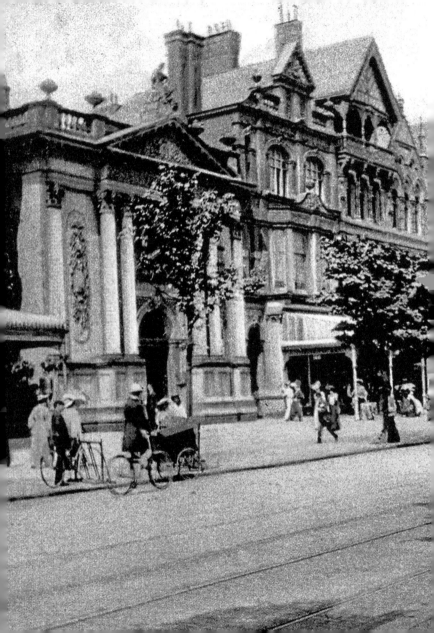

# 19. MIDLAND BANK

This side of the Albany, Britannia crowns the most extravagantly decorative of all Southport's banks. The original building of the Preston Bank – the first to open in Southport in 1857 – was replaced in 1888–89. On the left of the façade the old Southport crest and shield sports an open lifeboat changed later to a medieval ship. On the right, 'PP' (*Princeps Pacis*, Prince of Peace) emblazons the Preston town crest and shield.

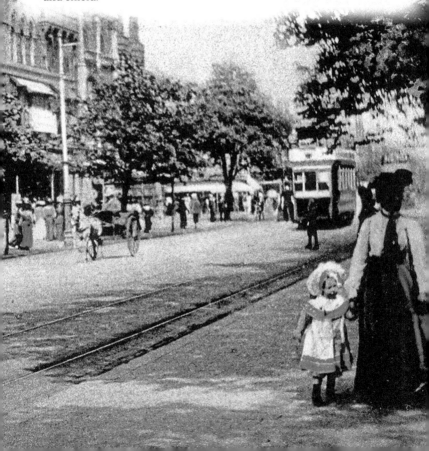

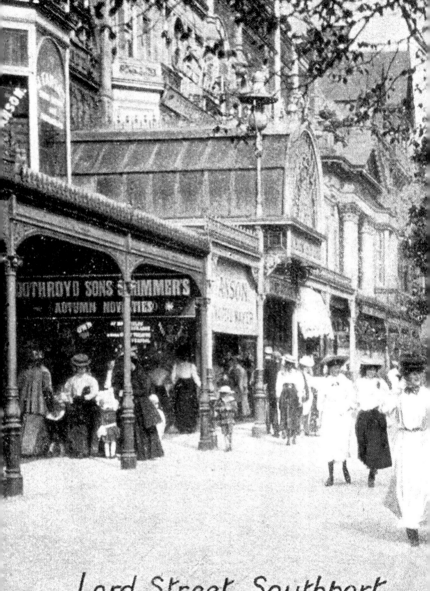

BOOTHROYD SONS & GRIMMER'S
AUTUMN NOVELTIES

Lord Street, Southport.

# 20. WAYFARERS ARCADE ENTRANCE

The Wayfarers Arcade, opened in 1898, was originally named Leyland Arcade (after the Liberal MP of the time) and in the 1960s the Burton Arcade. Its name is inset in brass in the paving at the entrance. The splendid cast-iron entrance canopy, supplied by Macfarlane's of Glasgow, compensates for the narrowness of the approach from Lord Street; the value of the frontage to Lord Street was considered too great for full fronted access.

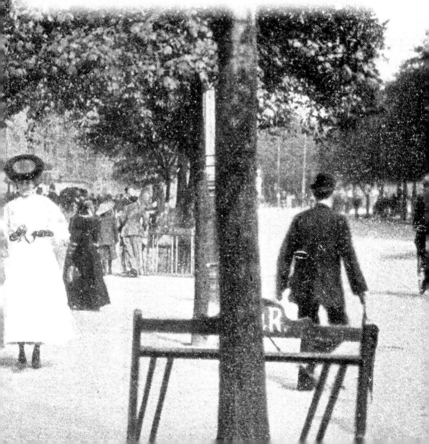

## 21. WAYFARERS ARCADE

It was intended to make Leyland Arcade a new way through to the Promenade, of which there are few from Lord Street, and beyond the widened out double-height conservatory is a grand staircase, but leading onto a narrow backstreet. There was a three-piece orchestra here between 1950 and 1959 led by Arthur Jacobson, pop recording star of 1928–33, dancing violinist and conductor of palm court orchestras. Now, Red Rum's statue claims attention.

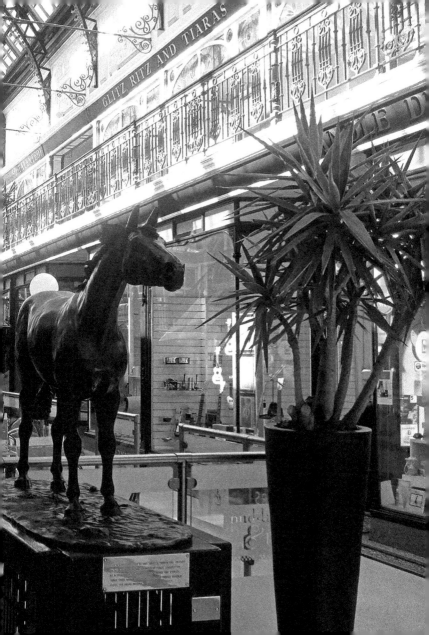

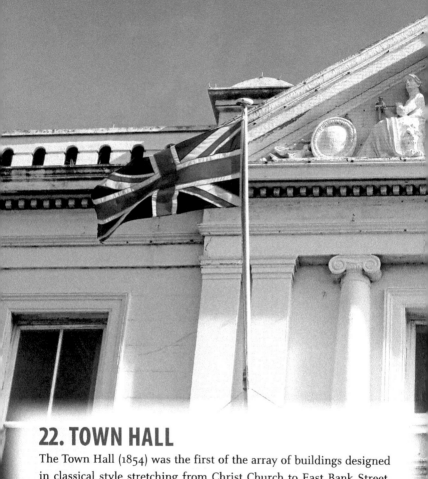

## 22. TOWN HALL

The Town Hall (1854) was the first of the array of buildings designed in classical style stretching from Christ Church to East Bank Street. Initiated by the Improvement Committee, it was designed and built by local men. Its crowning glory is the triangular pediment embellished with three figures: Justice in the centre with the scales of judgment, Mercy to the left sparing a prisoner and Truth to the right holding up a mirror to herself.

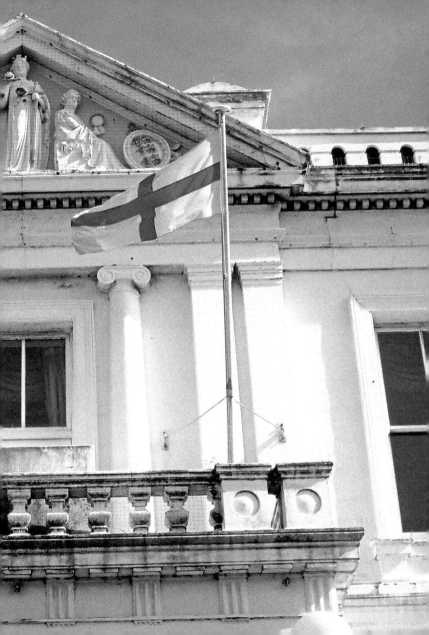

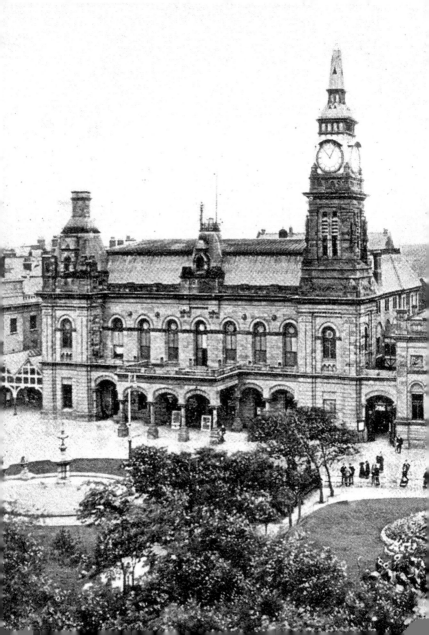

# 23. CAMBRIDGE HALL

Cambridge Hall (1874) was named after Princess Mary of Cambridge, mother of Queen Mary. It was designed for public meetings and entertainments. Then, in 1875, William Atkinson, a wealthy cotton manufacturer, donated an art gallery (now The Atkinson) and free public library, which was extended through into the buildings of the District Bank on the corner. A statue of Queen Victoria, unveiled in 1904 in place of the roundel of flowers, was later moved to the seafront.

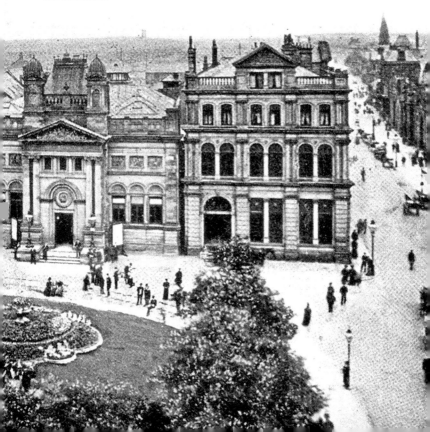

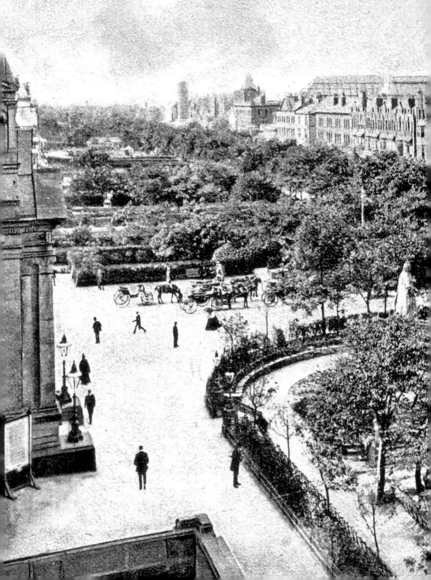

Lord Street from E., Southport

# 24. BANDSTANDS

Pictured is an early bandstand by the Town Hall with an enclosure that the public would pay to enter. At night crowds were attracted by the illuminated bandstand, fairy lights in the trees and elaborate fountains lit by electricity. The present bandstand on an inferior site further down Lord Street was designed by local architect Martin Perry and funded by Marks & Spencer's to celebrate the centenary of the opening of their first stall in Leeds in 1884.

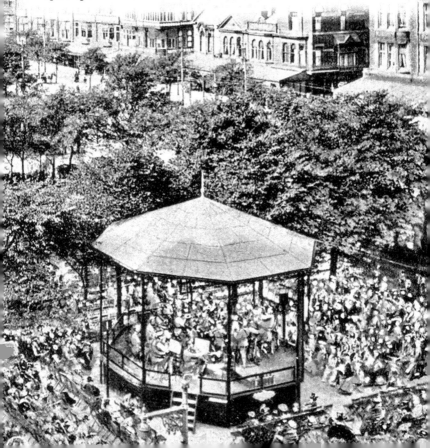

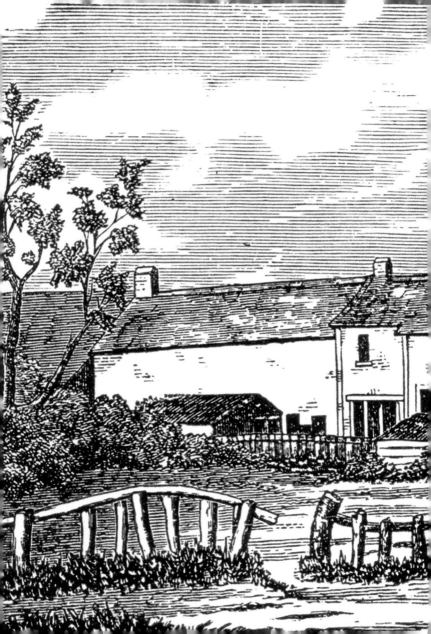

# 25. SOUTH PORT HOTEL

At the south-west end of Lord Street a brook, pretentiously dubbed the Nile, used to flow through the sand hills onto the shore. Near here 'Duke' William Sutton, landlord of the Hesketh Arms at Churchtown, built an inn called the South Port Hotel. This was demolished in 1854 when Lord Street was extended through to Birkdale, but a tablet set into the wall nearby preserves the memory of the 'The Duke's Folly'.

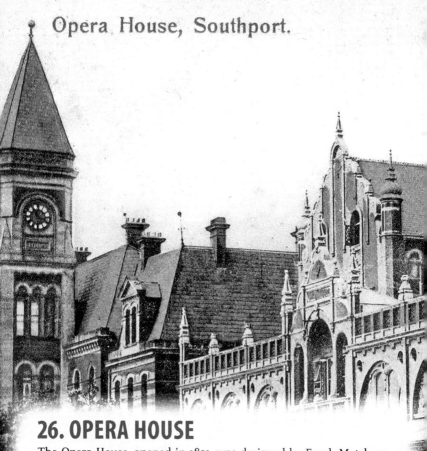

Opera House, Southport.

## 26. OPERA HOUSE

The Opera House, opened in 1891, was designed by Frank Matcham, who with his team created more than 200 theatres and variety palaces. Seating 1,492, it was part of the Winter Gardens entertainment complex between Lord Street and the Promenade created in 1874. The site encompassed a grand terrace on the Promenade side, a Crystal Palace-style conservatory stated to be the largest in England, a Promenade Hall and the Pavilion Theatre seating 2,500.

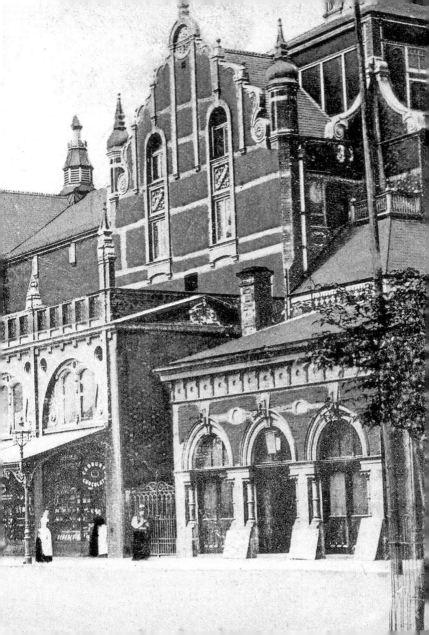

# 27. GARRICK THEATRE

When the Opera House burnt down in 1929 it was replaced by the Garrick. Seating 1,600, it boasted a stage to accommodate big productions with the latest lighting devices and scene-shifting mechanisms. A spacious foyer was decorated in Egyptian style and a broad thickly carpeted staircase led up to the circle lounge. For twenty-five years it produced every form of live entertainment from acrobats to pantomime and opera. Bingo took over in the 1960s.

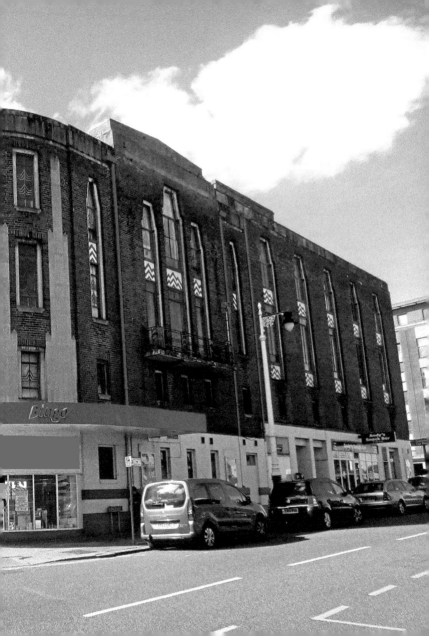

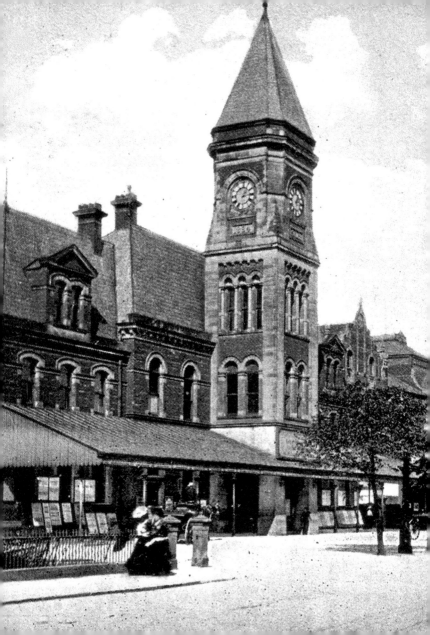

# 28. LORD STREET STATION

A plaque on the tower tells us that it was opened in 1884 as the terminus of the SCLER (Southport Cheshire Lines Extension Railway). It was perfectly situated next to the Winter Gardens and within easy reach of the beach, shops and major hotels. However, it struggled to compete with its rival on Chapel Street and closed in 1952. It became the station of the Ribble Bus Co., now used by a supermarket and Travelodge.

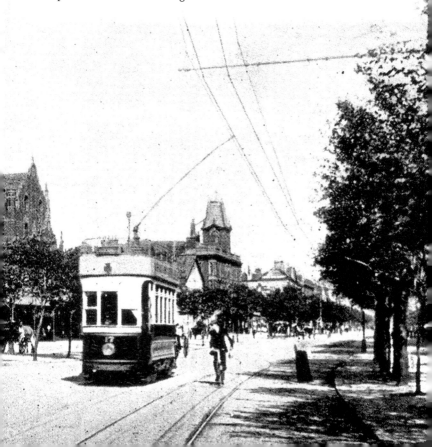

## 29. VICTORIA PARK AND ROTTEN ROW

The park was created in 1886 from land protected from the sea when the railway was extended from Birkdale to Lord Street. The herbaceous border stretching nearly half a mile along Rotten Row (named after London's) was formed in the early years of the last century and peaked at the time of the Flower Show (started in 1924). The show, the largest independent one in the country, was second only to Chelsea's.

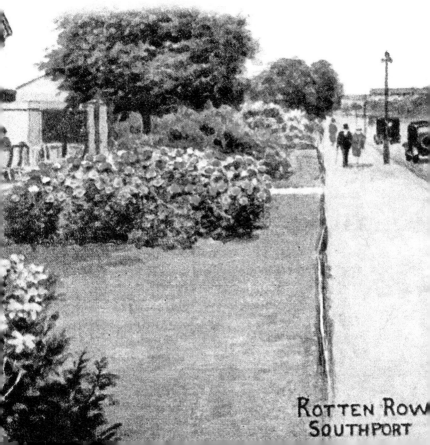

ROTTEN ROW
SOUTHPORT

## 30. ROYAL HOTEL

The Royal Hotel is a direct descendant of the 'The Folly', 'Duke' William Sutton's original structure of 1792 that was the making of Southport. When its successor was pulled down, the license was transferred to the Royal, which had been opened in 1853. This Edwardian view shows how the hotel vaults, accessed from the lower street level in Victorian times, were open to the public as a bar. The Promenade really was a promenade then!

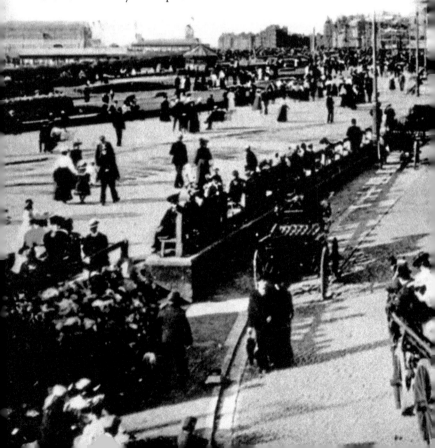

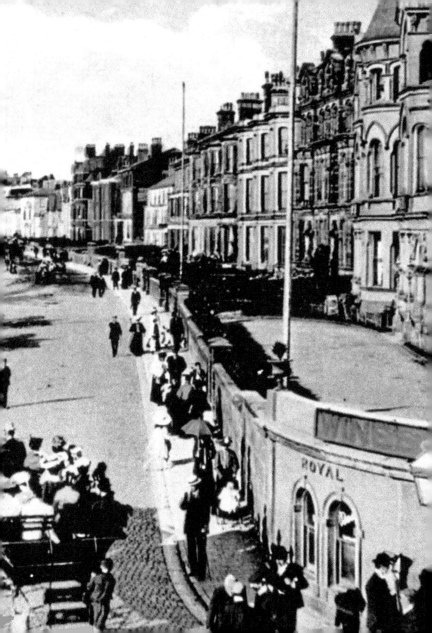

# 31. ROYAL CLIFTON HOTEL

The Italianate tower, just visible above the roof, is integral to the design of the hotel as it held the water tank. It also acted as a landmark in the Southport landscape, being effectively at fourth-floor level. The Clifton Hotel next door along the Promenade came under one ownership with the Royal in the 1970s. The single-storey octagons on the corner were added by local architect Martin Perry in the late 1980s.

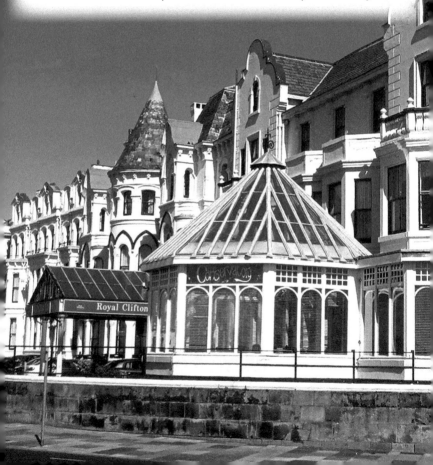

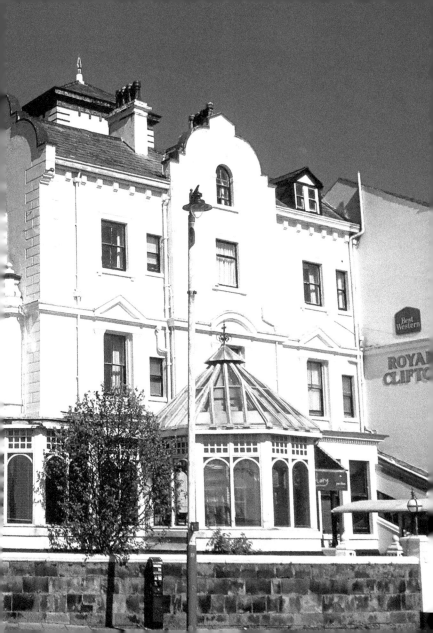

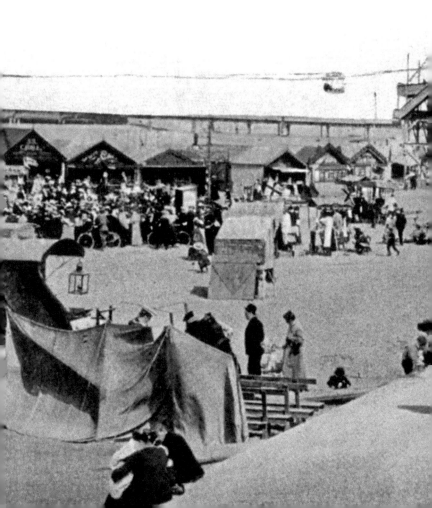

# 32. BEACH

The beach originally stretched right up to the present Promenade. When the Marine Lake was formed some of it was left for a while until it also was made into gardens. The tower of the Aerial Flight (in the centre of the picture) took you over the lake in a 'gondola'. Other attractions included a water chute, which precipitated you on boats into the lake, and the Maxim 'Captive' Flying Machine, which whirled you around in pods.

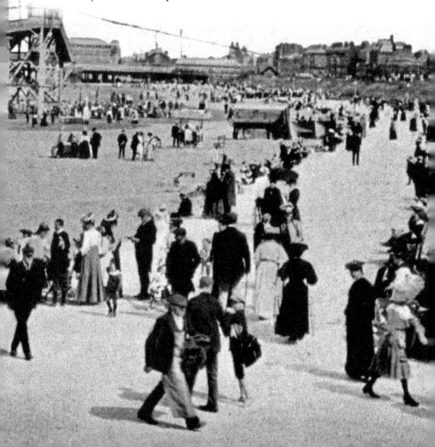

## 33. 'NEW' PROMENADE

When the Marine Lake was formed, a 'new' promenade was created alongside and the beach to the right landscaped into King's Gardens, opened by George V and Queen Mary in 1913. The new lakeside promenade was graced with elegant shelters and bandstand, and the gardens with an ornamental fountain and Arts and Crafts sports pavilion. In the distance is the Pier Pavilion. The Venetian bridge, now this side of the pier, had yet to be built – it was made in 1931.

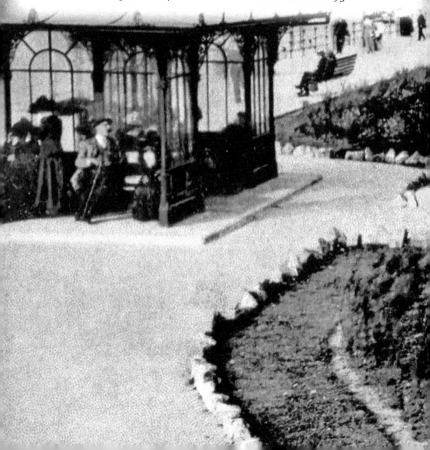

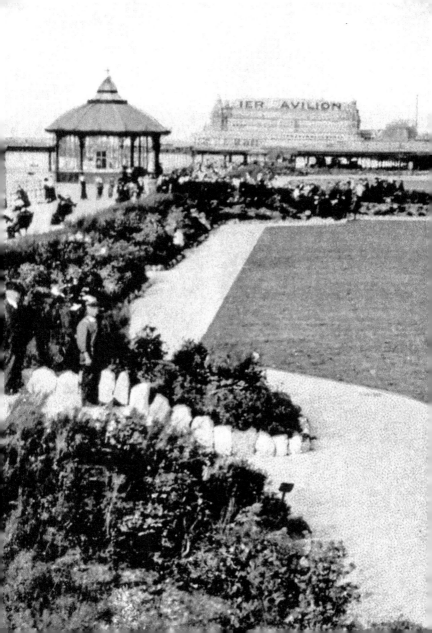

# 34. LIFEBOAT MEMORIAL

In 1886 an iron barque, the *Mexico*, was driven on to Birkdale sands. Fourteen of the crew of the Southport lifeboat *Eliza Fernly* and thirteen from the St Anne's boat *Laura Janet* perished in an attempted rescue but a boat from Lytham succeeded in rescuing the *Mexico's* crew of twelve. A fund for the bereaved, closed within a fortnight at a total of £30,000 (£3.5 million today), alleviated their poverty. Another memorial stands near the pier.

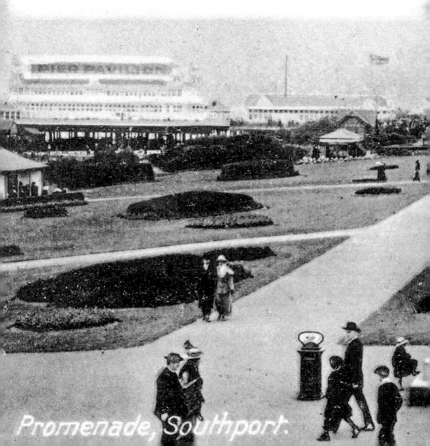

*Promenade, Southport.*

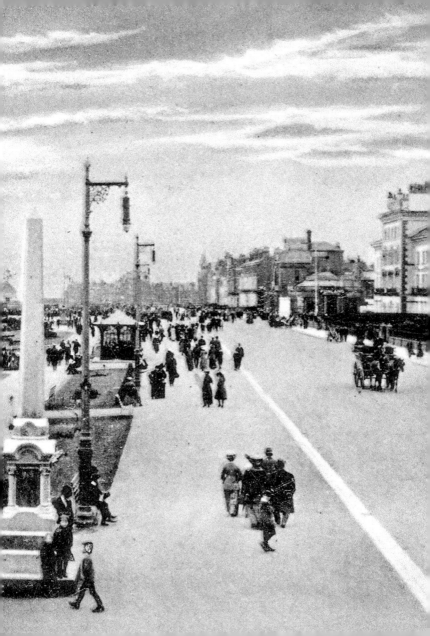

# 35. PIER CONSTRUCTION

Southport Pier was opened in 1860 at the height of the pier building era. It was the longest in the country, the first genuine pleasure pier and ingeniously constructed by pumping water down hollow iron legs that sank into the sand under their own weight. The pier's 1,200 yards were later extended by 260 yards to reach the deep water channel but have not been enough for the ships to sail for nearly a century.

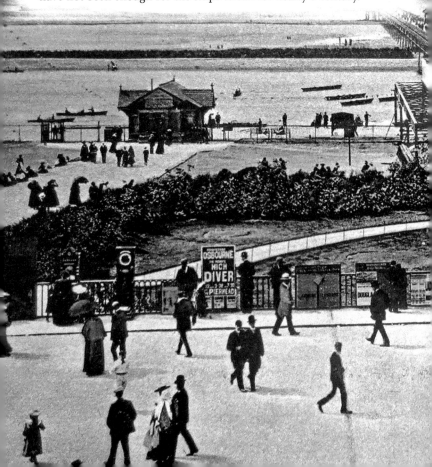

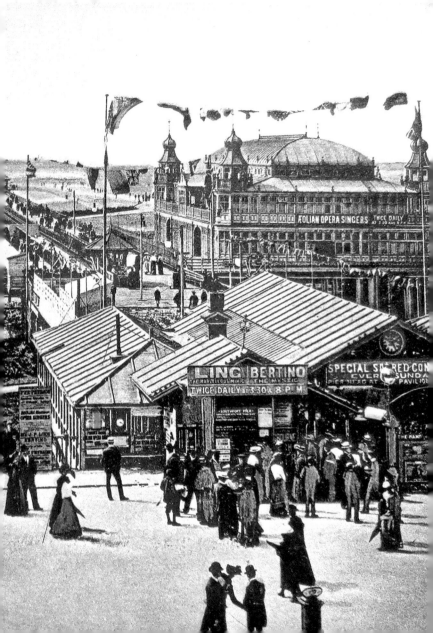

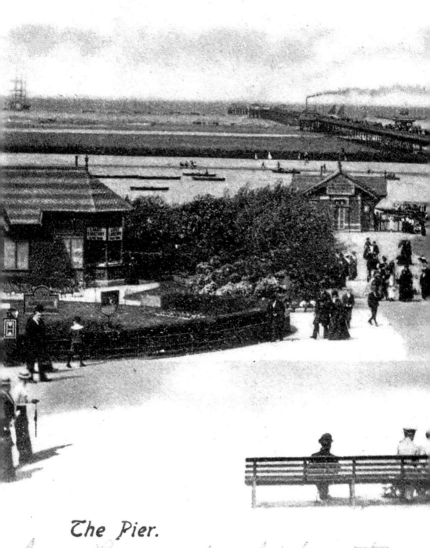

*The Pier.*

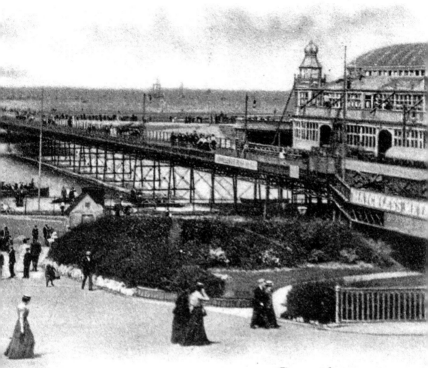

*Southport.*

## 36. PIER HEAD

It is hard to believe now, when the sea barely reaches the end of the pier, but steamships once berthed at the end of it bringing holidaymakers not just from Liverpool and Blackpool but as far as the Isle of Man and Anglesey (until the early 1920s). In this 1904 image sailing ships can be seen both sides of Southport Pier while a plume of smoke tells us that a steamship is at its head.

# 37. PIER AMUSEMENTS

Visitors could take a tram along the pier to a waiting room and refreshment room (swept away by a storm in 1889). People flocked to admire the distant scenery and the crowd of fishing boats and pleasure vessels at the head of the pier where a one-legged diver or the legendary Professor Powsey gave their diving displays. The 'Professor' would pedal off the edge of the pier, or dive on fire or tied up in a sack.

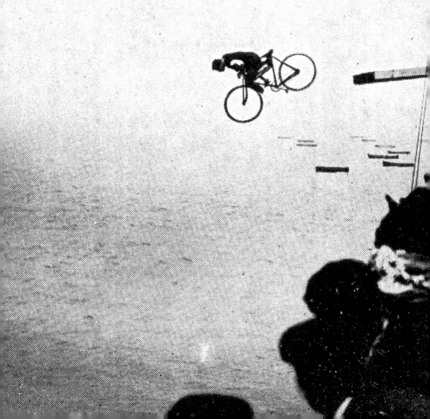

*Professor*
*Powsey'*
*sensational*
*Dive on a*
*Bamber..*
*Cycle....*
*Southport*
*Pier*
*Daily.*

# 38. PIER TRANSPORT

The tramway was horse drawn at first but later powered by steam to become the first cable-operated tramway for passengers in the world. Electrification came in 1905 and diesel haulage in 1950 when the pier lost its DC electricity supply. This in turn gave way to a battery-powered tram that weakened the structure and was recently sold to be replaced by a land train. The pier was saved from threatened closure in 1990.

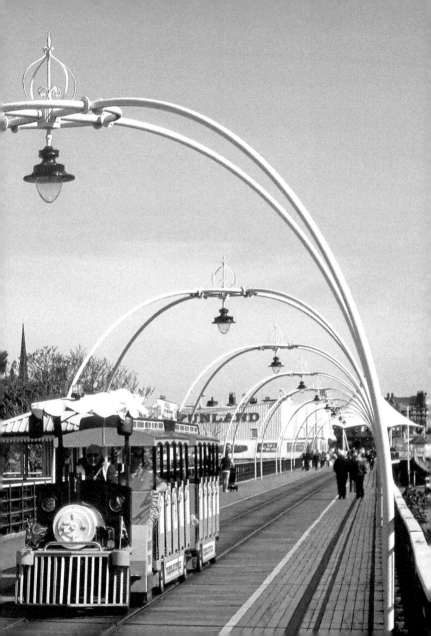

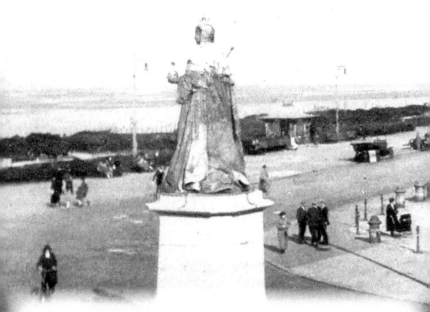

## 39. VICTORIA BATHS

In the 1830s 'scores of men in a perfect state of nudity' were bathing and ladies were 'compelled to witness or keep aloof from the shore'. So the Victoria Baths opened in 1839 with a procession, enjoyment of the facilities and celebratory dinner. A steam engine provided power to draw water from the shore and heat the conservatory. The Victoria statue has since been turned and now faces the town (why?).

Queen     Victoria     Statue     and     Promer

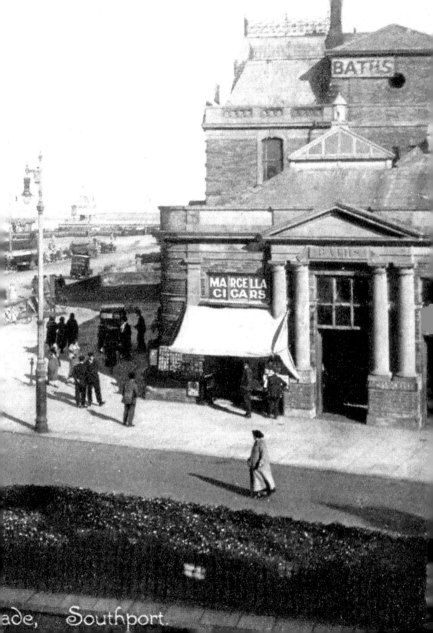

BATHS

MARCELLA
CIGARS

BATHS

ade, Southport.

# 40. FLORAL HALL AND NORTH LAKE

Sir Peter Fleetwood Hesketh of Meols Hall pioneered the construction of a sea wall and promenade starting in 1835. The family's other homes at Rossall and Heysham had given them experience of sea bathing. The South Lake was created in 1887 and the North Lake in 1892, which were joined later. The Floral Hall was built in the 1930s as a conference centre and is now a multipurpose venue with the Southport Theatre being added in 1973.

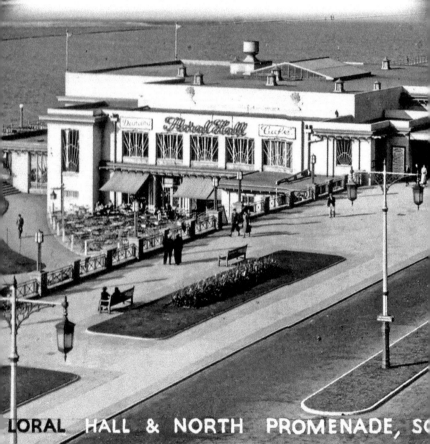

LORAL  HALL & NORTH  PROMENADE, SO

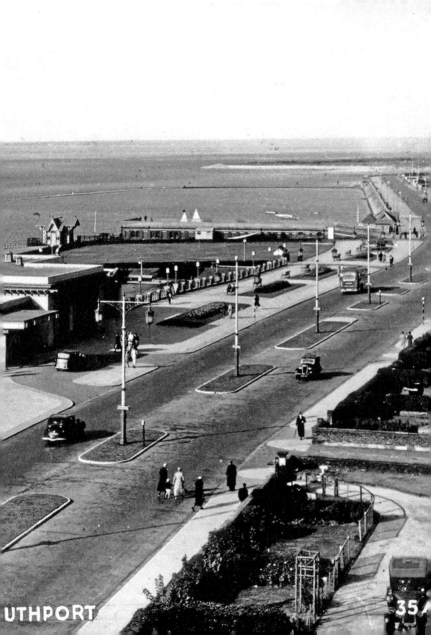

UTHPORT

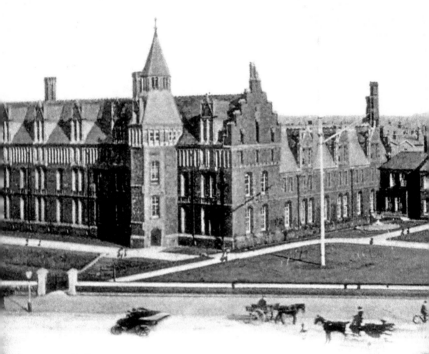

# 41. PROMENADE CONVALESCENT HOSPITAL

The elegant two-storey building was built in 1853 and the grand block added in 1883. It was founded by a charity whose subscribers had the right to nominate one 'sick, poor stranger' who would receive money to board for three weeks in Southport. The hospital housed soldiers during both world wars and stayed voluntary until taken over by the National Health Service in 1948. It then treated acute medical conditions until closing in 1990.

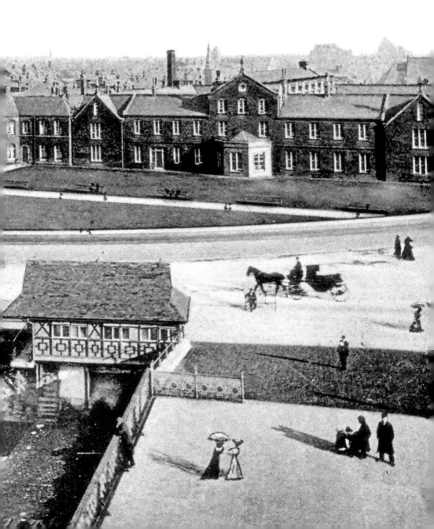

Convalescent Hospital
Southport.

# 42. BIRKDALE PALACE HOTEL

Manchester merchants mainly funded this hotel, which opened in 1866. However, handicapped by its remote position, it was declared bankrupt in 1881. Revived immediately as a hydropathic establishment, it benefited from the opening of the Cheshire Lines Railway and its Birkdale Palace station (just the other side of it in the aerial photo). It was demolished in the 1960s to make way for housing except the coach house, now The Fisherman's Rest pub on Weld Road.

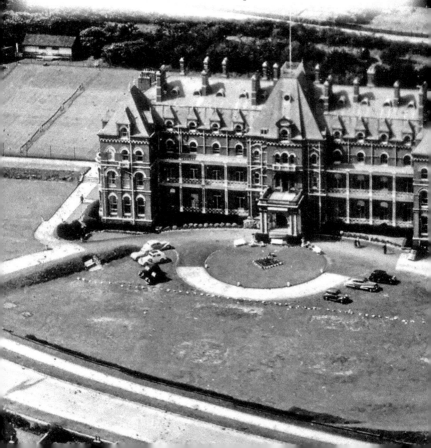

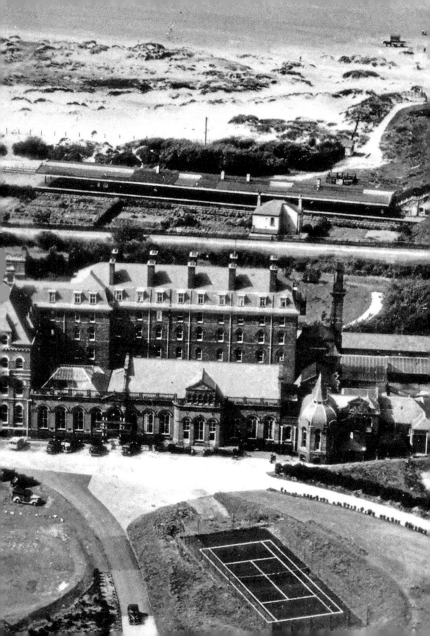

# 43. BIRKDALE TOWN HALL

Before the age of the motorcar, the road was hogged by tram and horse. Cycling on the pavement was a safer option! Built to accommodate the newly formed Local Board, just before becoming an urban district council, the Town Hall with its tower dates from the early 1870s. It was demolished in 1971 to make way for redevelopment. This side of it, the police station and magistrates' court were opened in the early 1890s.

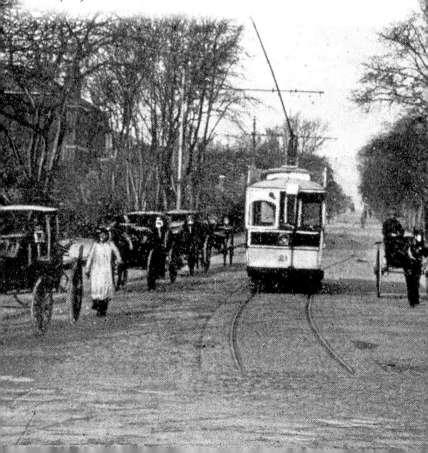

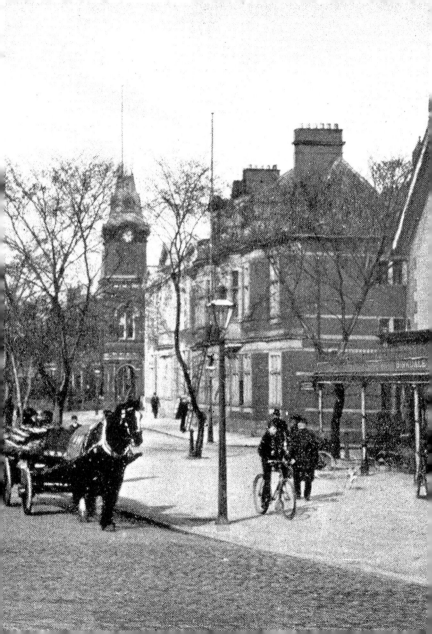

# 44. SMEDLEY'S HYDRO

The Hydro adopted the system of treatment pioneered by the late John Smedley at Matlock. It was opened in 1877 with Dr Barnardo, brother of the founder of Dr Barnardo's homes, as its medical director. The neighbouring Birkdale Park estate had been marketed as a health resort and contained a large proportion of people living off unearned income – more women than men. Its success inspired the conversion of the Palace Hotel to hydrotherapy.

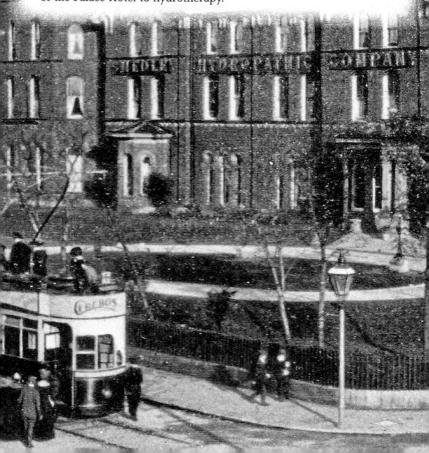